ANNE GEDDES ®

www.annegeddes.com

© 2002 Anne Geddes

The right of Anne Geddes to be identified as the Author
of the Work has been asserted by her in accordance with the
Copyright, Designs and Patents Act 1988.

First published in 2002 by Photogenique Publishers
(a division of Hodder Moa Beckett)
Studio 3.11, Axis Building, 1 Cleveland Road, Parnell
Auckland, New Zealand

This edition published in North America in 2002
by Andrews McMeel Publishing
4520 Main Street, Kansas City, MO 64111-7701

Produced by Kel Geddes
Color separations by Image Centre
Printed in China by Midas Printing Ltd, Hong Kong

ISBN 0-7407-2284-0

ANNE GEDDES

Thoughts *with* Love
for Mothers

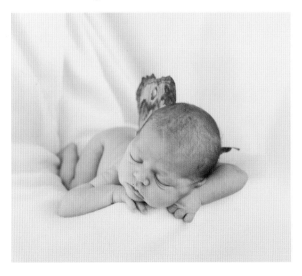

*O*h! little lock of golden hue,
 In gently waving ringlet curl'd,
By the dear head on which you grew,
 I would not lose you for a world.

Lord Byron (1788–1824)

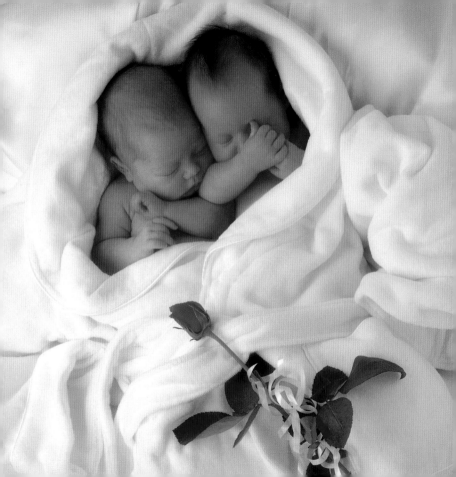

There are only two lasting bequests
we can hope to give our children.
One of these is roots;
the other, wings.

Cecilia Lasbury

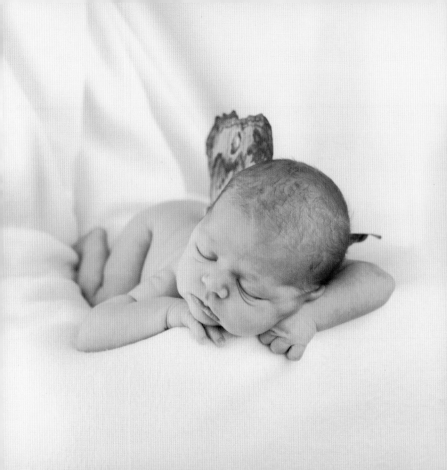

*S*ome are kissing mothers
and some are scolding mothers,
but it is love just the same,
and most mothers kiss and scold together.

Pearl S. Buck (1892–1973)

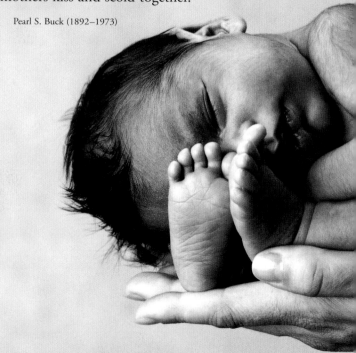

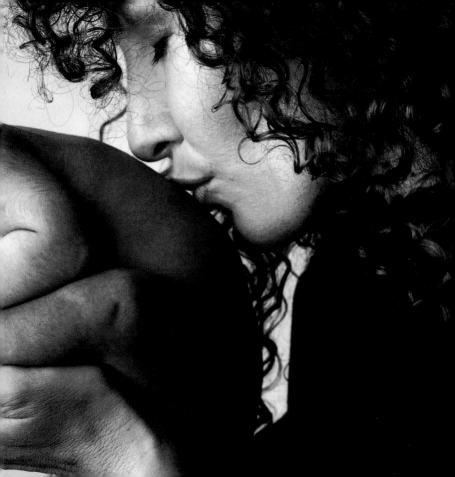

*Nothing grows in our garden,
only washing.
And babies.*

Dylan Thomas (1914–1953)

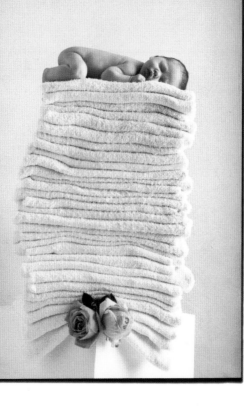

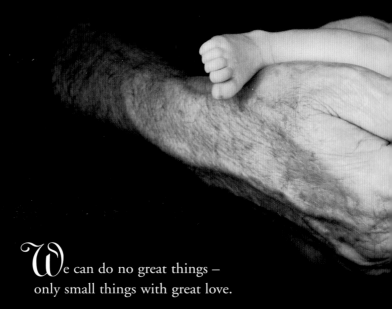

\mathcal{W}e can do no great things –
only small things with great love.

Mother Teresa (1910–1997)

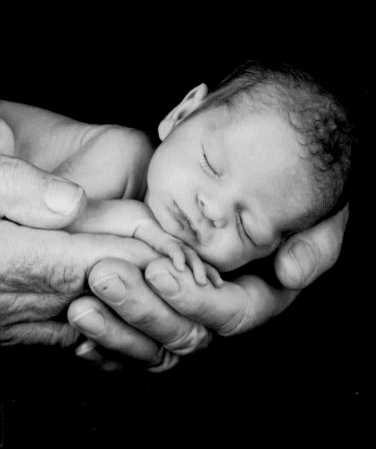

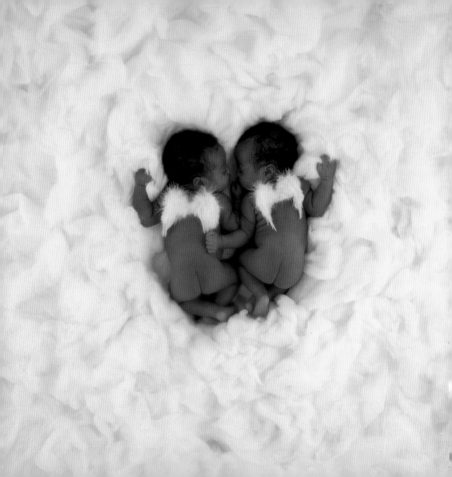

*Kiss your children goodnight,
even if they are already asleep.*

H. Jackson Brown, Jr. (1940–)

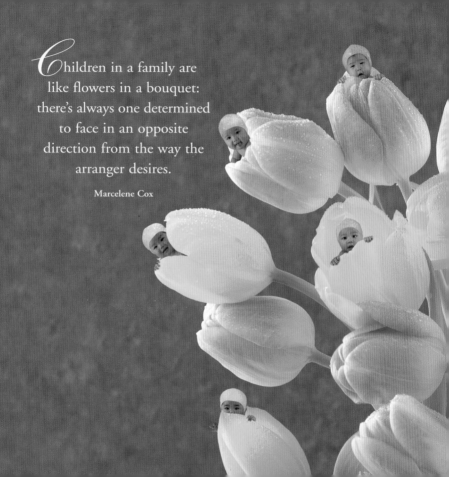

Children in a family are
like flowers in a bouquet:
there's always one determined
to face in an opposite
direction from the way the
arranger desires.

Marcelene Cox

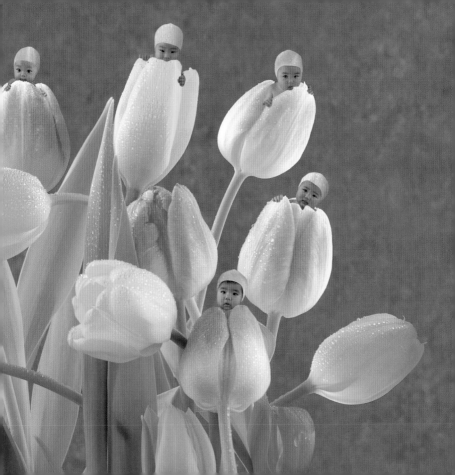

You too, my mother, read my rhymes
For love of unforgotten times,
And you may chance to hear once more
The little feet along the floor.

Robert Louis Stevenson (1850–1894)

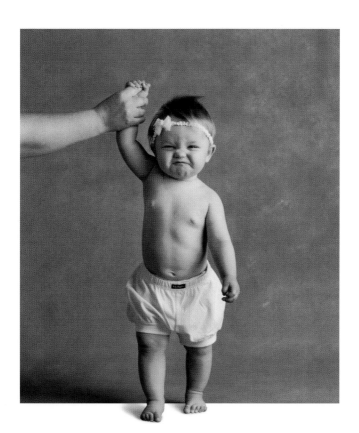

A mother understands
what a child does not say.

Proverb

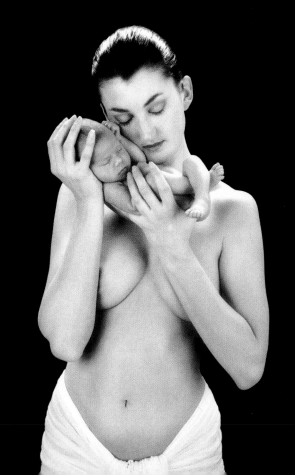

A perfect example of minority rule
is a baby in the house.

Anonymous

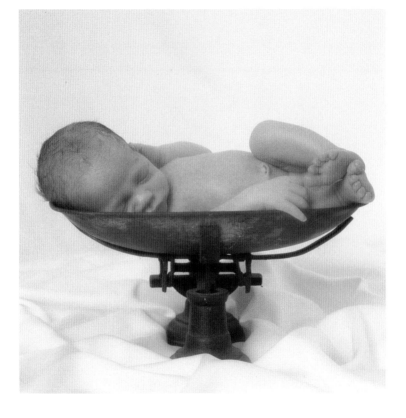

*W*hisper in your sleeping child's ear,
"I love you."

H. Jackson Brown, Jr. (1940–)

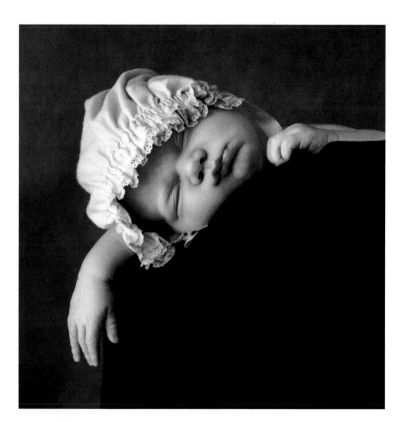

\mathcal{I}t was the Rainbow gave thee birth,
And left thee all her lovely hues.

William Henry Davies (1871–1940)

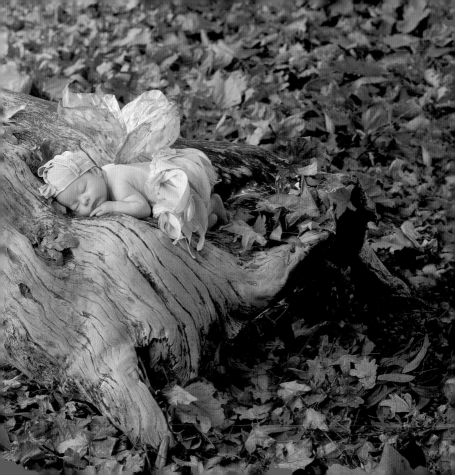

Each day I love you more ...
today, more than yesterday ...
and less than tomorrow.

Rosemonde Gérard

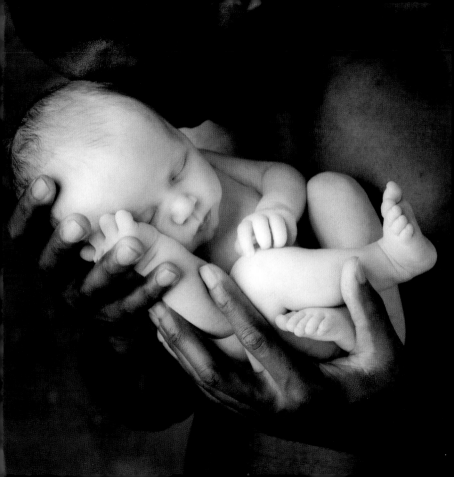

The decision to have a child
is to accept that your heart will forever walk about
outside of your body.

Katharine Hadley

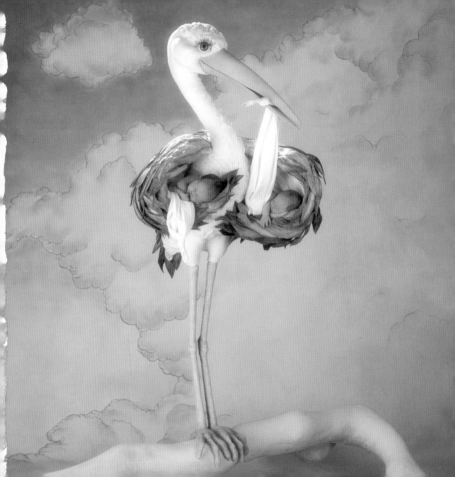

*F*or babies people have to pay
A heavy price from day to day –
There is no way to get one cheap.
Why, sometimes when they're fast asleep
You have to get up in the night
And go and see that they're alright.
But what they cost in constant care
And worry, does not half compare
With what they bring of joy and bliss –
You'd pay much more for just a kiss.

Edgar Guest (1881–1959)

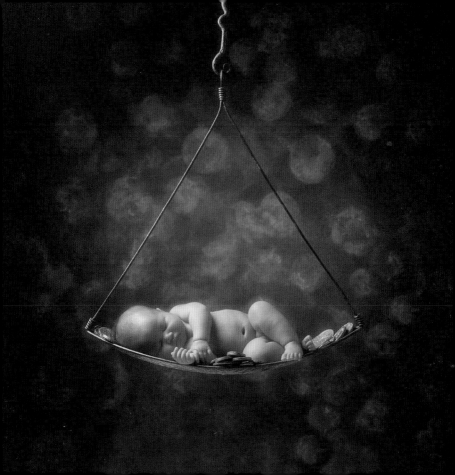

The greatest gift is a portion of thyself.

Ralph Waldo Emerson (1803–1882)

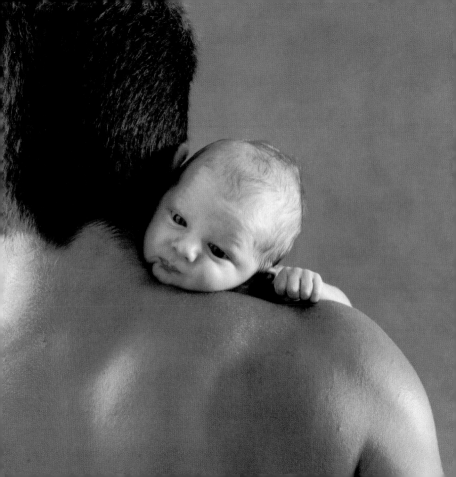

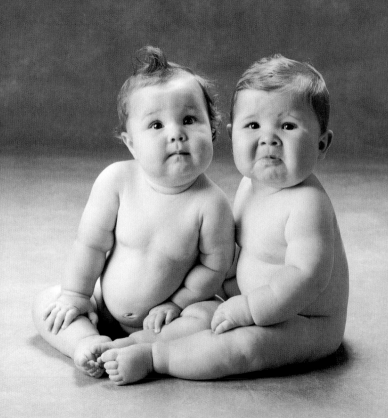

When you havva no babies –
you havva nothing.

Italian immigrant woman

*Golden slumbers kiss your eyes,
Smiles awake you when you rise:
Sleep, pretty darling, do not cry,
And I will sing a lullaby.*

Thomas Dekker (1572–1632)

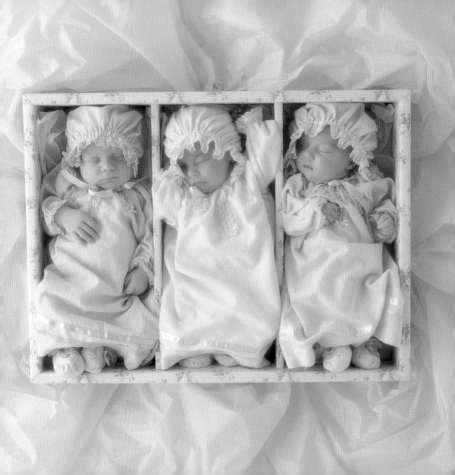

*I*t lay upon its mother's breast, a thing
Bright as a dewdrop when it first descends,
 Or as the plumage of an angel's wing,
Where every tint of rainbow beauty blends.

Amelia Welby (1821–1852)

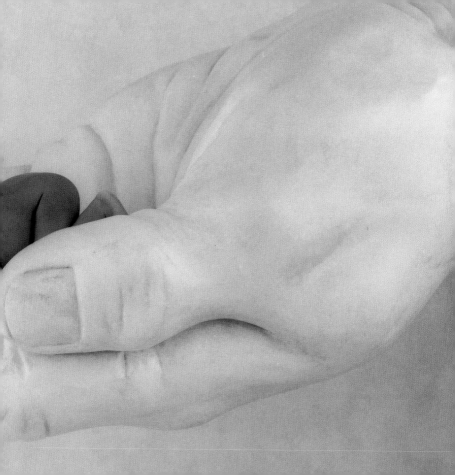

ACKNOWLEDGMENTS

The publisher is grateful for the permission to reproduce those items which are subject to copyright. While every effort has been made to trace copyright holders, the publisher would be pleased to hear from any not here acknowledged.

The quotation from *Great Quotes from Great Women* © 1997 Successories, Inc., is reprinted with the permission of Career Press, PO Box 687, Franklin Lakes, NJ 07417.

The quotations from *Life's Little Instruction Book Volume III* © 1995 H. Jackson Brown, Jr., are reprinted with the permission of Rutledge Hill Press, Nashville, Tennessee.

FURTHER INFORMATION ABOUT THE QUOTATIONS

(in alphabetical order by author)

Kiss your children goodnight …
Whisper in your sleeping child's ear …
H. Jackson Brown, Jr. (1940–), American writer, from *Life's Little Instruction Book Volume III*, Rutledge Hill Press, USA, 1995

Some are kissing mothers …
Pearl S. Buck (1892–1973), American novelist

Oh! little lock of golden hue …
from "To A Lady" (1806)
Lord Byron (1788–1824), English poet

There are only two lasting bequests …
Cecilia Lasbury, quoted in a speech by Hodding Carter II (1907–1972), American writer and political commentator

It was the Rainbow ...
William Henry Davies (1871–1940),
English poet, from his poem "The
Kingfisher"

Golden slumbers kiss your eyes ...
Thomas Dekker (1570–1632),
English dramatist

The greatest gift ...
Ralph Waldo Emerson (1803–1882),
American poet and essayist

Each day I love you more ...
Rosemonde Gérard, from "L'Eternelle
Chanson"

For babies people have to pay ...
Edgar Guest (1881–1959), American
writer, from "What a Baby Costs,"
A Treasury of Great Moral Stories,
Simon and Schuster, 1993

The decision to have a child ...
Katharine Hadley, from "Labours of
Love," *Tatler*, May 1995

We can do no great things ...
Mother Teresa (1910–1997), from
Great Quotes from Great Women,
Career Press, USA, 1997

You too, my mother, read my rhymes ...
Robert Louis Stevenson (1850–1894),
Scottish author

Nothing grows in our garden ...
Dylan Thomas (1914–1953),
Welsh poet, from *Under Milk Wood*
(1954)

It lay upon its mother's breast ...
Amelia Welby (1821–1852),
American poet